Images & Words

by

Michael R. Ebert

authorHOUSE

AuthorHouse™
1663 Liberty Drive
Bloomington, IN 47403
www.authorhouse.com
Phone: 833-262-8899

Published by AuthorHouse 08/25/2023

ISBN: 978-1-4259-1824-8 (sc)
ISBN: 978-1-4678-0117-1 (e)

Print information available on the last page.

This book is printed on acid-free paper.

"Most people don't take snapshots of the little things.
The used band-aid.
The guy at the gas station.
The wasp on the jello.
But these are the things that make up the true picture of our lives."

—Seymour Parrish (played by Robin Williams)
in the 2002 movie, "One Hour Photo."

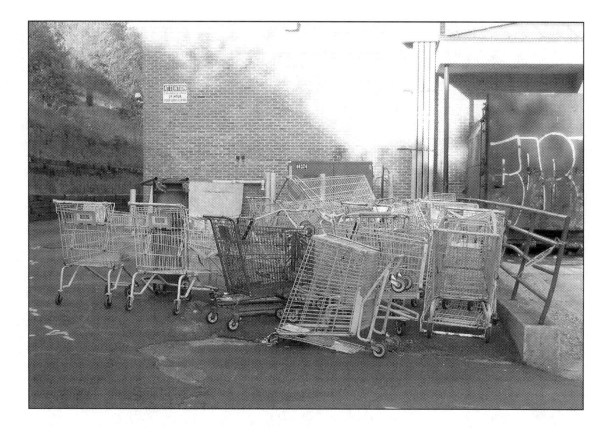

I prefer shopping carts with one bad wheel. Those are the ones
I always choose. If I pick a perfect cart, I'll push it aside.
I'll give it up. I want a neglected, broken cart.
A deformed cart. A cart that nobody else wants.
A cart that nobody else would choose.

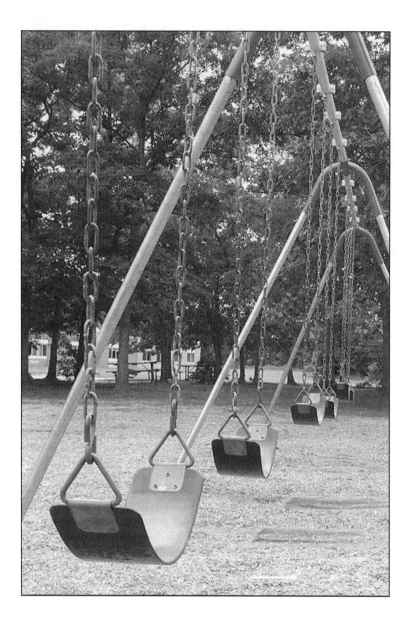

I used to visit a playground everyday. But one day I stopped.
I'm not sure when, but somewhere between adolescence and
adulthood I bid farewell to my childhood haunt.
It happened suddenly. I always expected I'd visit
the beloved location again. But I never did.

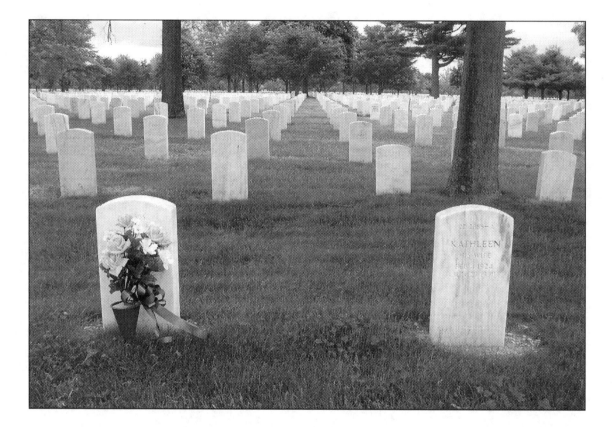

I visit my grandmom's grave every year. And my granddad's
too. But while there, I also visit strangers. I stare across
the sea of sandstone stretching as far as the eye can see.
Hundreds of forgotten lives surround me. Thousands.
And one day, I'll be forgotten too.

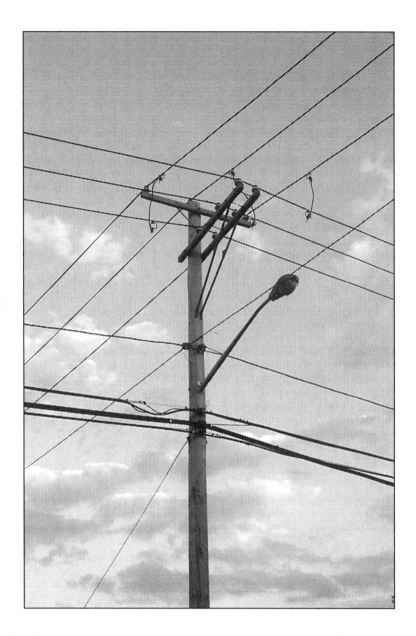

I recall climbing trees as a child. I'd grab a drooping branch and hoist myself up. I'd vanish into the leaves. But today's trees are too tall to climb. And there's no foliage.
There's wiry woodland along every roadway,
but their electric limbs only litter the sky.

I strolled along the riverside recently. And I brought some
bread for the ducks. But I didn't need it. There was no
fowl to feed. There wasn't much river to enjoy either.
Yet, man was everywhere. And he had Mother
Nature's legs spread against her will.

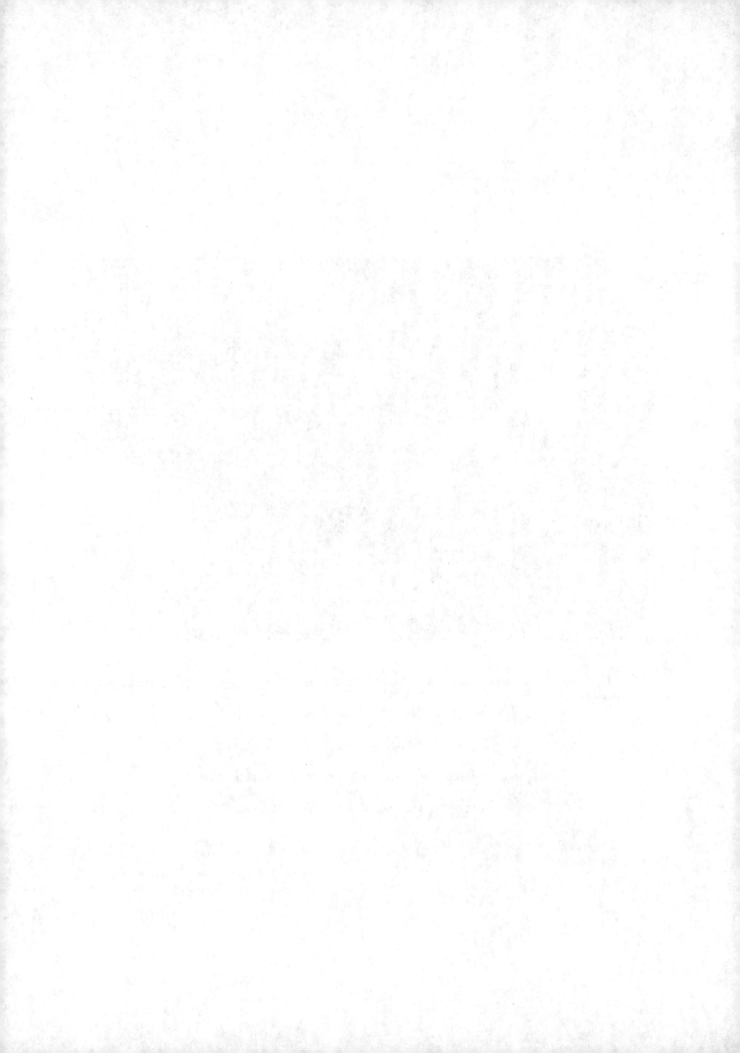

I stumbled upon a cluster of signs recently. I was driving through a suburban street, and the billboards emerged unexpectedly. Sofas. Nails. Pizza. Everything was posted. And every bit of land was ad-filled. Businesses battled for a passerby's eye. For a dollar.

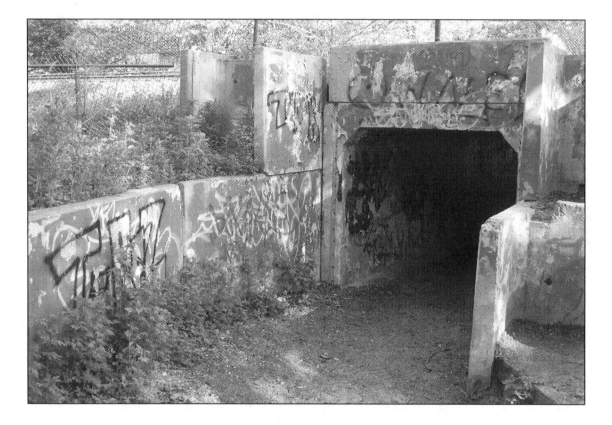

I've never created graffiti. But I often stop to read it. I study
the designs closely. Every letter. Every shape. Every color.
They all began as thoughts in somebody's head.
But they don't last. They're rapidly erased from the world.
So I enjoy the fleeting show.

I keep my lights off, if possible. I prefer pitch-black rooms.
I prefer darkness. But most people shrink from shadows.
They balk at being blind. They seek brightness. They need to
know what's happening in the world around them.
They can't see enough.

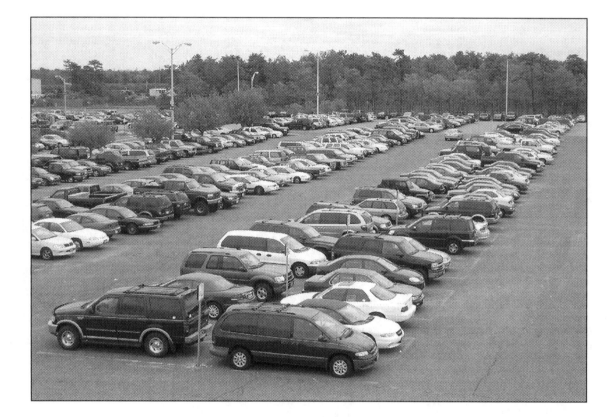

I cringe at packed parking lots. Empty automobiles sitting
silently give me chills. It's a morgue of metal and chrome.
A ghost town. And the owners are nowhere in sight.
They're shopping. Or working. They're gripped in busy lives.
And endless, cyclic tasks.

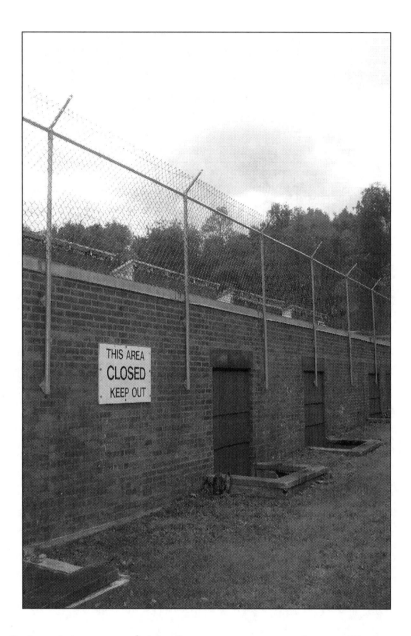

I live behind fences. Whether at work or home, I'm protected
by padlocks or walls. And my pocket is filled with dozens of
keys, all of which help hide precious possessions. We buy
things. We flaunt things. And after we create envy,
we lock the jealous ones out.

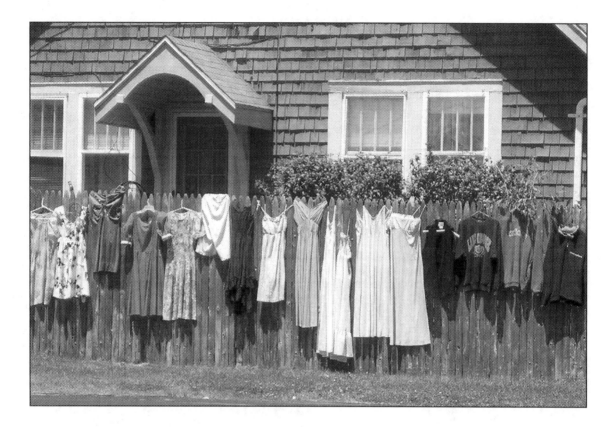

I grimace at garage sales. I shield my eyes. The sight is simply
too upsetting. Items, once loved, are old and unwanted.
They're cast off to strangers for pocket change.
They're propped up for show. It's a parade of rejection.
A freak show. And I can't look.

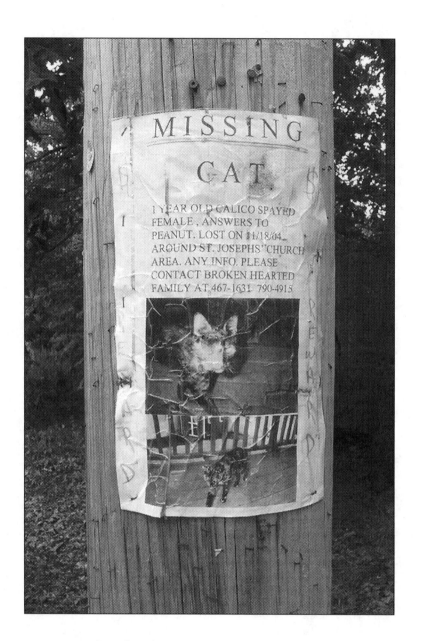

I saw a weather-beaten, missing cat sign recently. The
calico's name was "Peanut." And the family was admittedly
"brokenhearted." Solemnly, I studied the feline's photo.
I memorized its color and size. Then I drove off,
envisioning the would-be reward money.

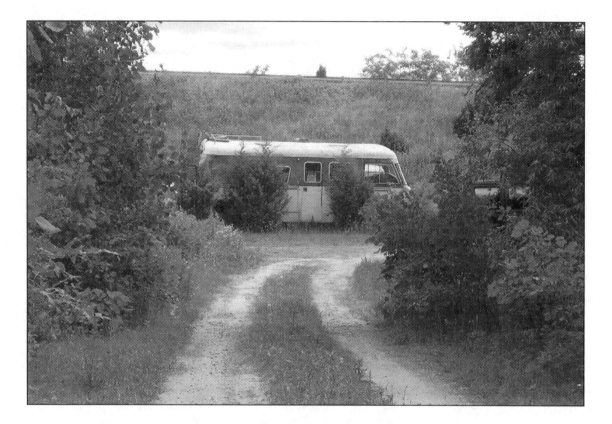

I followed a boy recently. He was walking in the woods,
but not for a scenic stroll. He was actually heading home.
A ramshackle van appeared amongst a cluster of trees.
And without hesitation, he hopped inside.
He hugged his mother. And he shut the door.

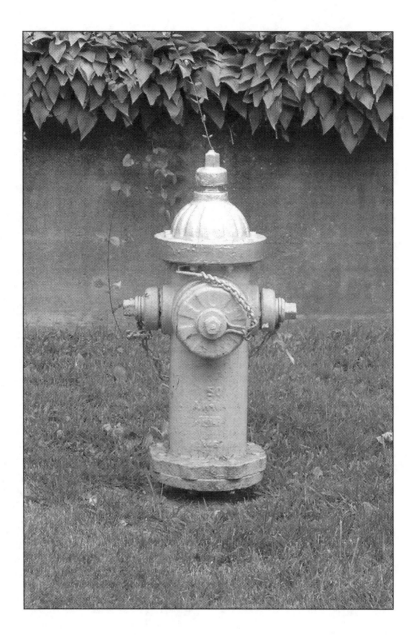

I see dozens of fire hydrants everyday. Hundreds.
But I never really notice them. They're purely part of the
daily landscape. They're overlooked. Ignored. But one day,
a faithful hydrant will awaken. It'll play hero. Savior.
Only to vanish again seconds later.

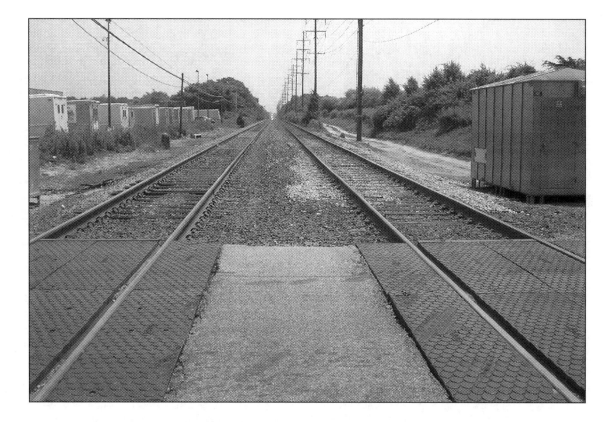

I hate to travel. I prefer staying close to home. Familiar
surroundings comfort me. But people are always in motion.
While some go east, others go west. Some say hello,
while others say goodbye. We move in circles.
On paths so close they nearly converge.

I grew up in a town. On a road. On a block. Just like everyone else in this world. It was where I learned to walk. Learned to talk. Learned who I am, and how to survive. But my road is one of many. Every block is someone's special place. Every town is home.

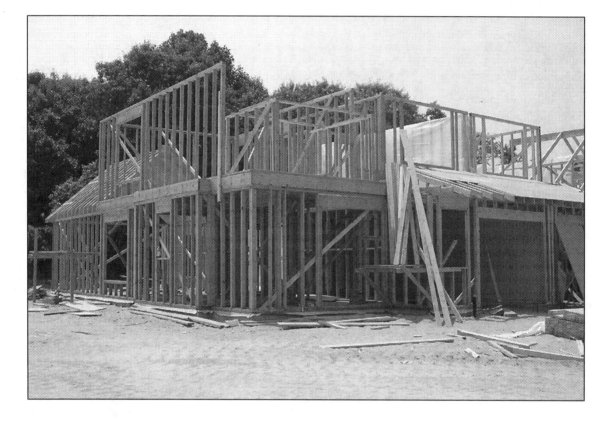

I passed a construction zone recently. Wood was everywhere.
But no family yet. The home was just a skeleton.
It was being brought to life. Blood was being pumped in,
one nail at a time. And newlyweds would be smiling soon,
oblivious to what stood before.

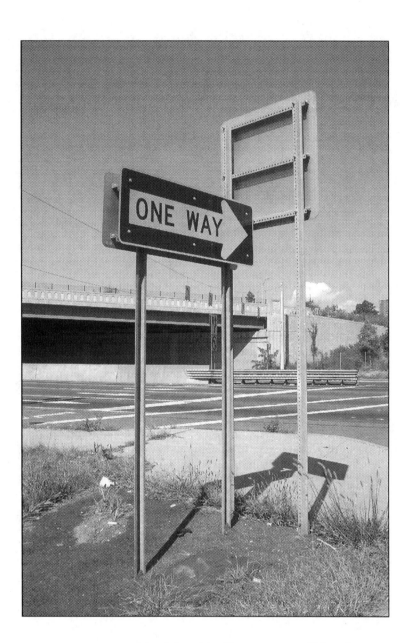

I despise street signs. Yield. No Parking. There's a command
on every corner. There's bossiness on every boulevard.
Instead of exploring Earth at my own enjoyment,
I'm bullied into boundaries. I'm caged.
The world is off-limits, unless the sign consents.

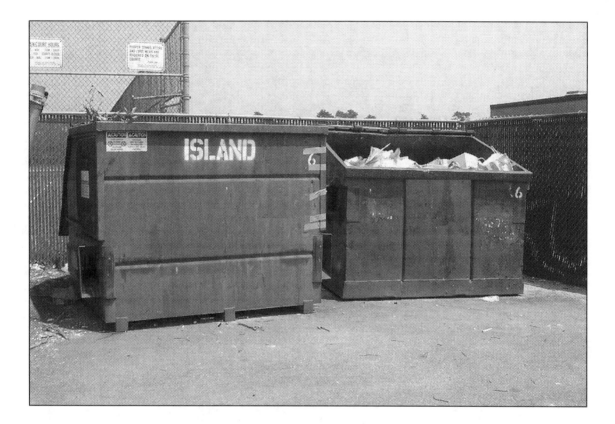

I see dozens of dumpsters everyday. Everywhere I go,
garbage is close at hand. Stores. Offices. Apartments.
Items that once lined shelves are tossed into the burial bin.
And without a worry, new products will replace them.
Just like people replace people.

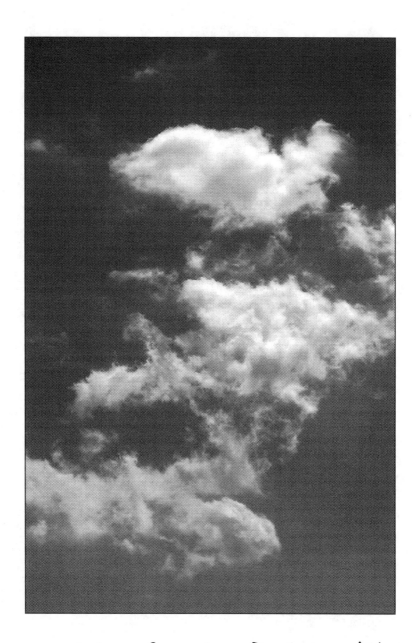

I favor overcast skies. Gray skies. Dark skies. Whenever I see
a cotton-like cloud, I look away. They're a big, spongy tease.
They form faces. They smile. They laugh. But before long,
they're back to bleakness. Back to threats of rain.
And shadowy skylines.

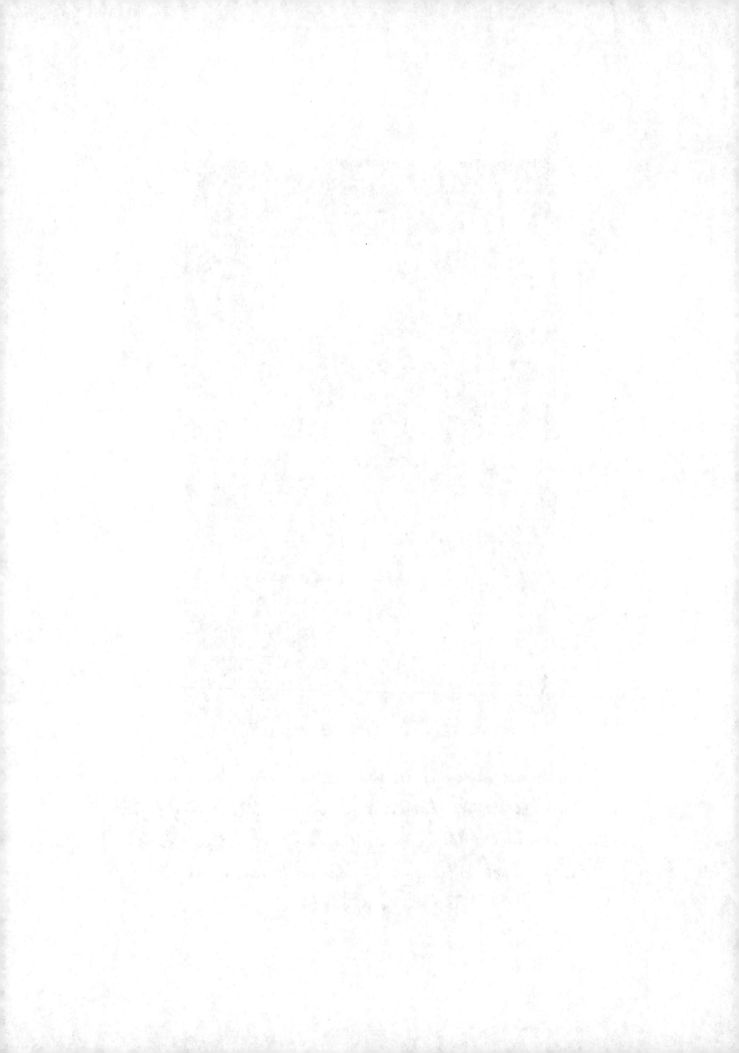

I rarely use public bathrooms. The smells. The noises.
It's a nauseating experience. I could never "do business" with
someone inches away. But I do use the sinks. And mirrors.
I make sure I look presentable. It's a superficial society.
And I feel compelled to conform.

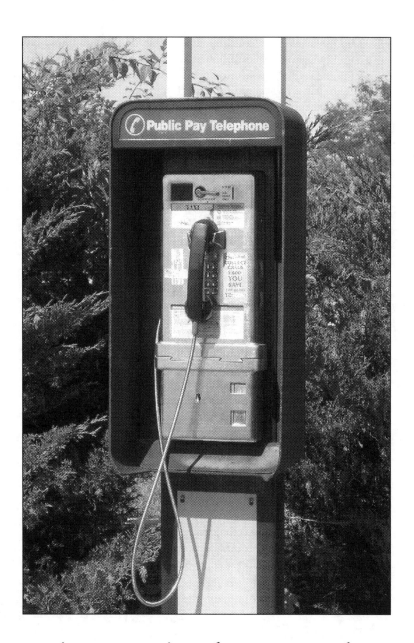

I see payphones everywhere. Street corners. Storefronts.
But they're never in use. They're outdated. Obsolete.
Like old typewriters. Or aging athletes. They stand silently,
watching the world evolve around them. Begging for
a passerby's touch. And fading away.

I don't drink alcohol often. But many people, young and old, make liquor their lives. It's their motivation to survive a stressful day. Their escape. Their way of entertainment. But they're feeding themselves false fun. They're not truly happy. It's all a pathetic act.

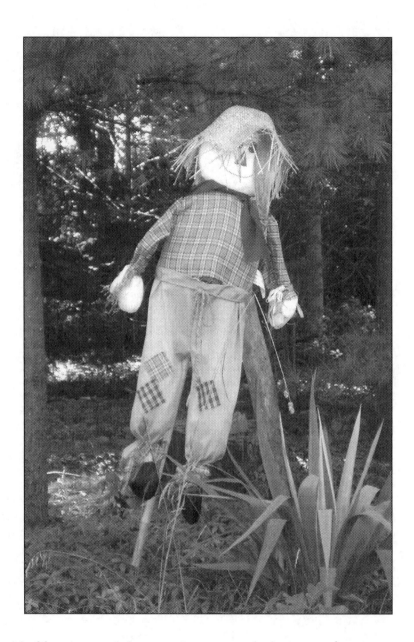

I like Halloween. It's my favorite holiday. And scarecrows
are my favorite decoration. They're a fleshless face and
bloodless body, but they appear real. They grin. They gaze.
But besides the straw, they're empty inside. And sadly,
that's their most lifelike feature.

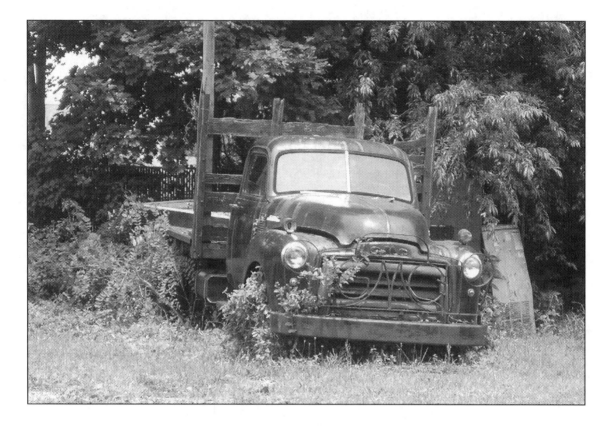

I admired an old truck recently. It was deserted.
And the years weren't kind to it. Weeds and rust ruled.
But there was a time when this archaic automobile was
just a pup. It was pristine. The center of attention.
But all things grow old. All heydays sadly halt.

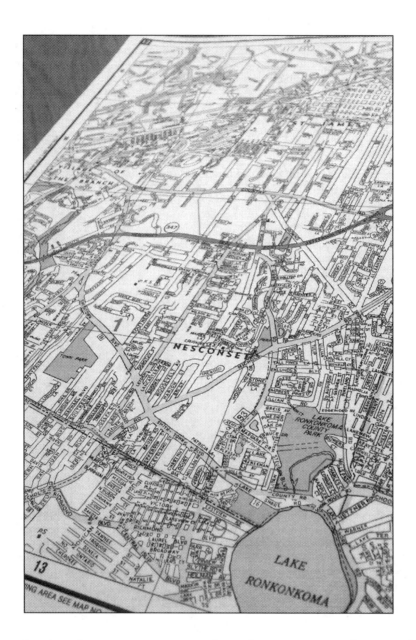

I studied a large map recently. It was tucked on a back
shelf at my local library. Squinting, I found my town.
My street. But the tiny words were lost in the grid's vastness.
Lost in the throng of other streets. Other towns.
And other places I'd probably never see.

I notice flags everywhere lately. On shirts. Bumpers. Lawns.
Everywhere I turn, I'm face-to-face with red, white and blue.
People jumping aboard the partisan bandwagon.
But I've never bought a flag. And I don't plan to.
I refuse to submit to forced patriotism.

I spotted something above the leaves recently. It was very tall.
But it was no tree. It hovered like an alien craft,
dwarfing the surrounding landscape. It looked out of place.
But nobody cared. It was just part of the panorama.
The backdrop. The modern horizon.

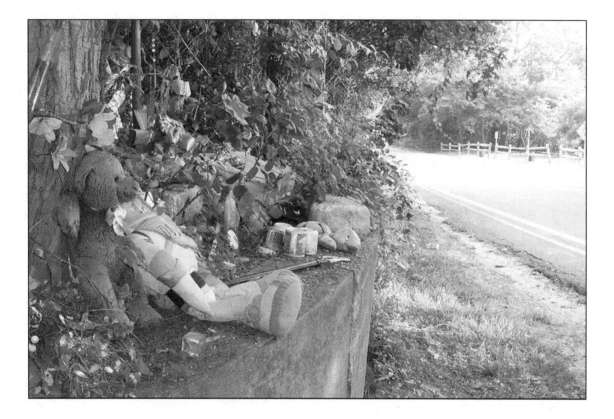

I pass a toy collection on the roadside everyday.
Stuffed animals. Action figures. It's a toddler's wet dream.
But a family's worst nightmare. At that very spot,
a life lapsed. Blood spilled. Breathing stopped.
And we drive by without more than a passing glance.

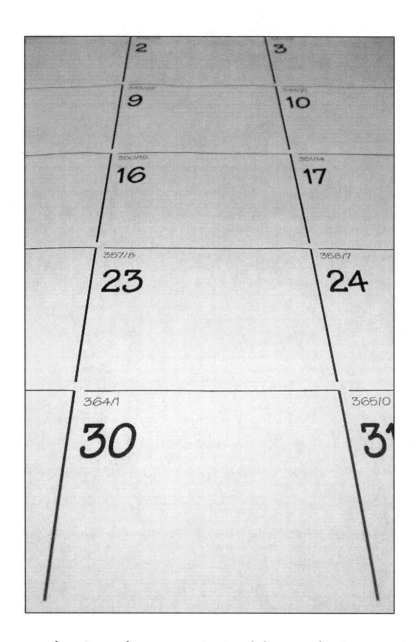

I have a calendar above my desk. It's neatly fastened to the
wall of my cubicle. It tells me the day. Month. And year.
And it allots space to scribble some appointments.
But I never use it. I leave it blank. I know life moves fast.
And I'd rather not count days.

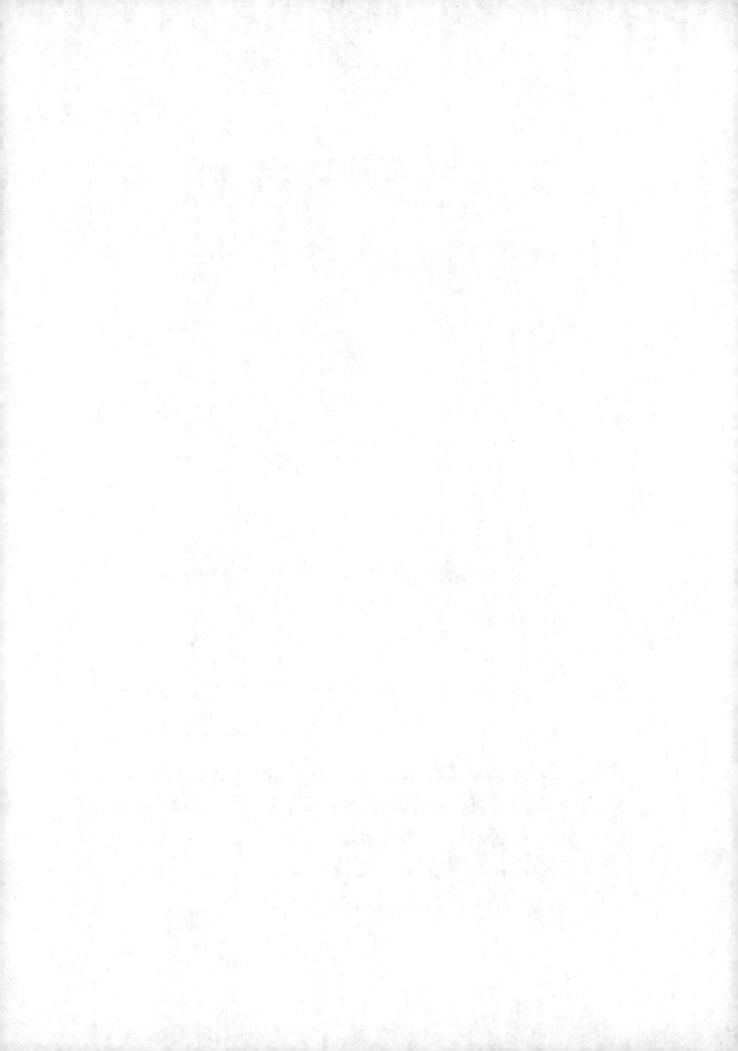

I haven't been fishing in years. But as a child, my father took
me every summer. We'd buy bait. We'd pack a cooler.
We'd hit the water. I never really caught anything,
but it didn't matter. It was a chance to get away.
Just a rod. A reel. And a restful hush.

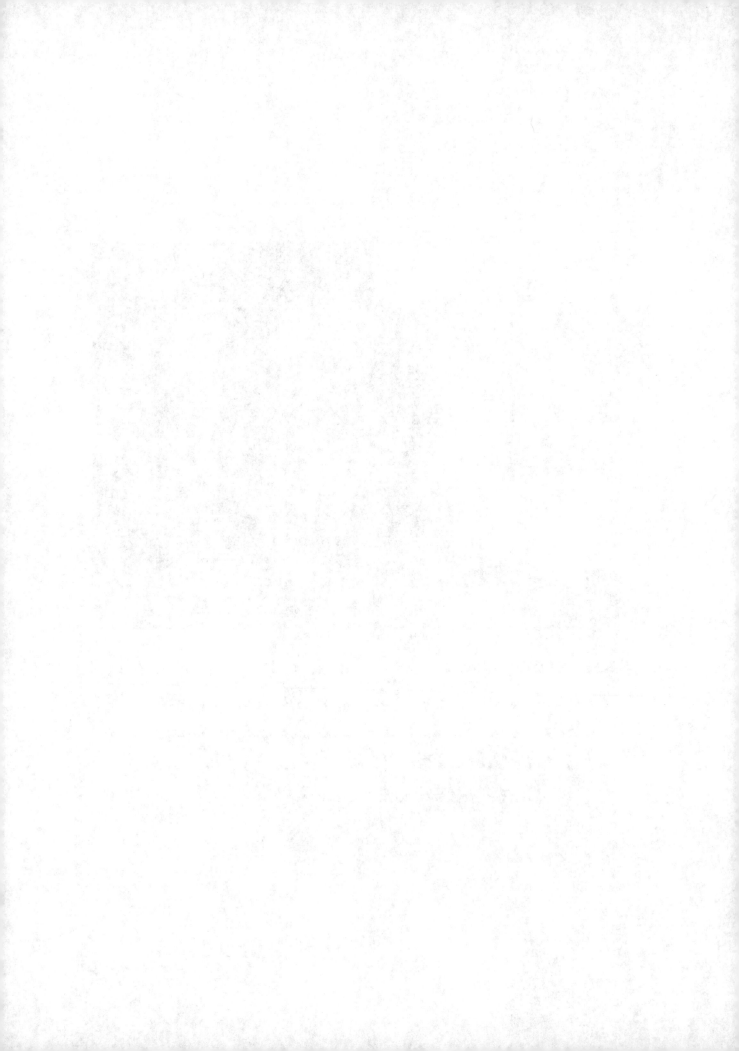

I read the newspaper everyday. First, the sports section.
Then news. Then gossip. It's a world's worth of information
for two quarters. But tomorrow, the print is dated.
Pages move from newsstands to dusty shelves.
Words go unread. Except on that one day.

I eat take-out two or three times a week. But I don't go
inside. I use the drive-thru. Today's civilization is all about
speed. Fast food. Fast transportation. Fast technology.
Every second counts. Every minute is meaningful.
We're all in a big rush to go nowhere.

I rarely ride elevators. I prefer stairs. Trusting a sealed
mechanical box irks me. But today, elevators are essential.
Floors are stacked like jumbo decks of playing cards,
and every nook is taken. People kiss clouds.
Higher is superior. And stairs are just too slow.

I hiked through a local forest recently. And I unexpectedly encountered a bulldozer. Piles of earth were casually tossed around. Trees were flattened. It's undeveloped land, people say. Vacant. But if you ask me, it was already in use. It was bursting with life.

I have a remote control for my TV. And VCR. And DVD
player. And stereo. They are devices controlling devices.
Batches of buttons with dozens of choices. We sit.
We stay still. Let the actors and athletes jump around.
We'll just watch them in wonder.

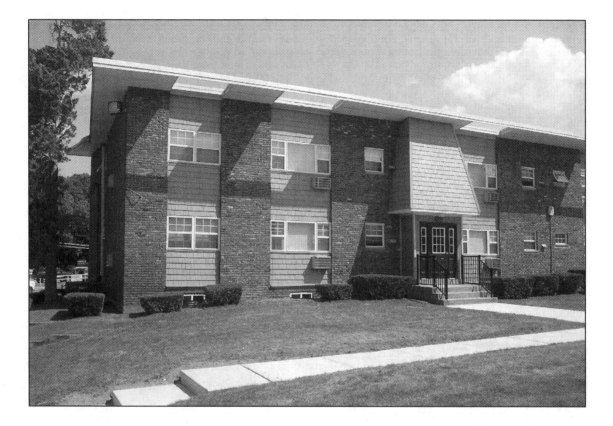

I've lived in apartments much of my adulthood.
But I rarely speak to my neighbors. We nod hello. We smile.
We wordlessly hold open doors. They're just faces in a
window. Names on a mailbox. But behind each door
is a complicated life. And pain. And dreams.

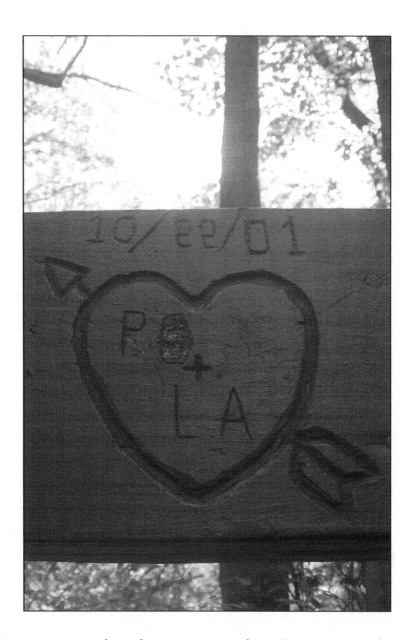

I hiked in my local park recently. I admired the trees.
Stream. And carved initials. At that spot, two young souls
once experienced passion. And they left their mark. Today,
they might be miles apart. Light years apart.
But their love lingers. It never dies.

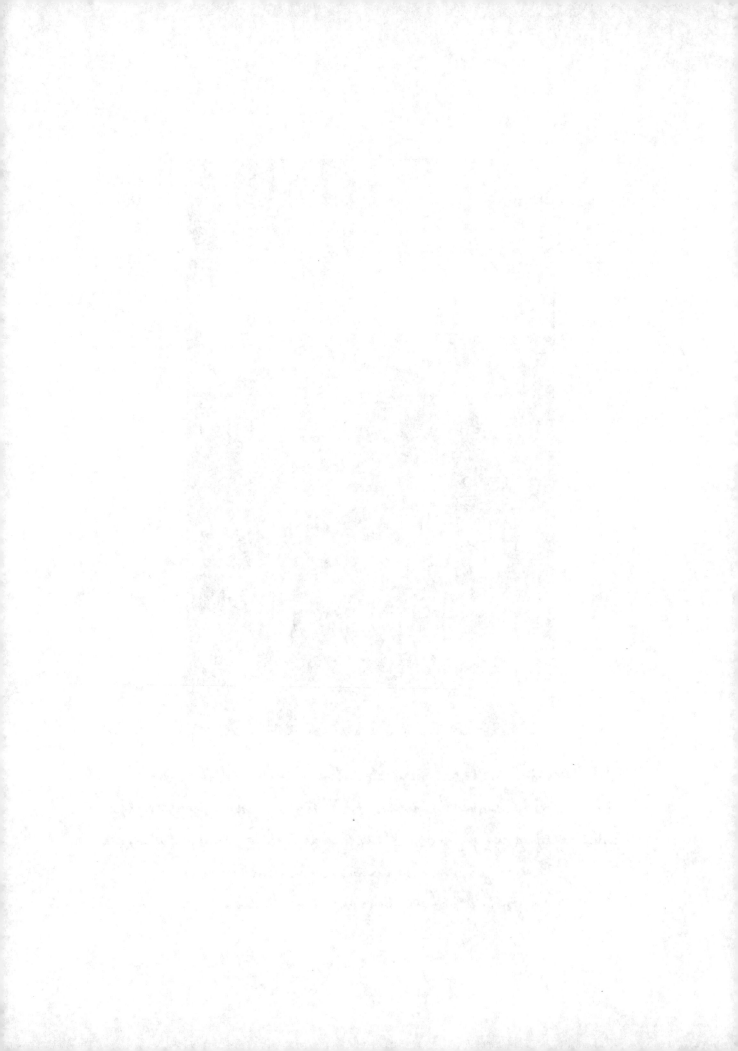

I visit the post office every week. I buy stamps. And I dump my
envelopes in a box. But I'm not alone. Everyone mails things.
Divorce papers. Love letters. Eviction slips.
There's a story behind each sealed flap. A broken heart.
A lucky lover. A ruined family.

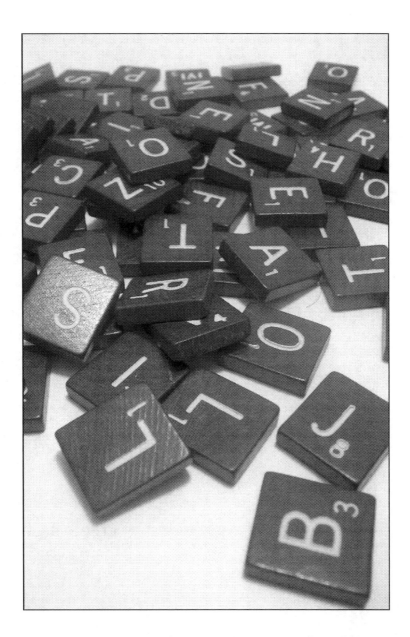

I avoid board games. Chess. Checkers. Scrabble. It's war
disguised as recreation. With a smirk, we fight friends for
bragging rights. We vex them. We label them losers.
But if you ask me, life and love are competitive enough.
Tiny tiles just make things worse.

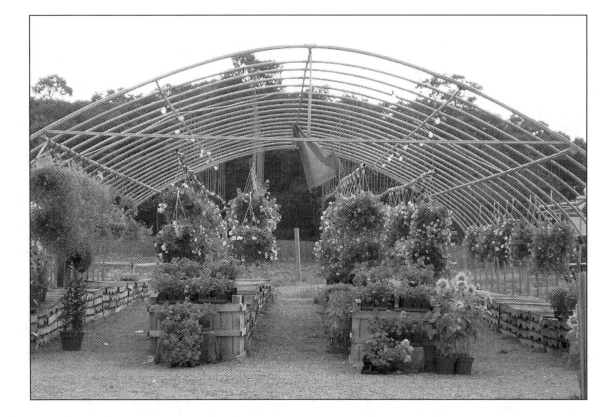

I passed a roadside greenhouse recently. Flowers and plants
sat side-by-side. Tiny price tags hung from each pot.
It was a whorehouse of horticulture. A floral brothel.
People perused petals. Stems. Then they whipped out
a wallet for one of Earth's offspring.

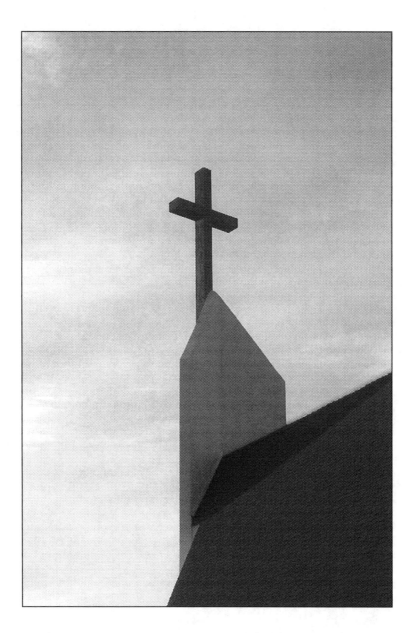

I haven't been to church in years. But as a child, I joined
my parents every Sunday. We'd recite prayers. We'd talk
to God. We'd beg for mercy. If my words were heard,
I'll never know. But my presence pleased my parents.
And that was good enough for me.

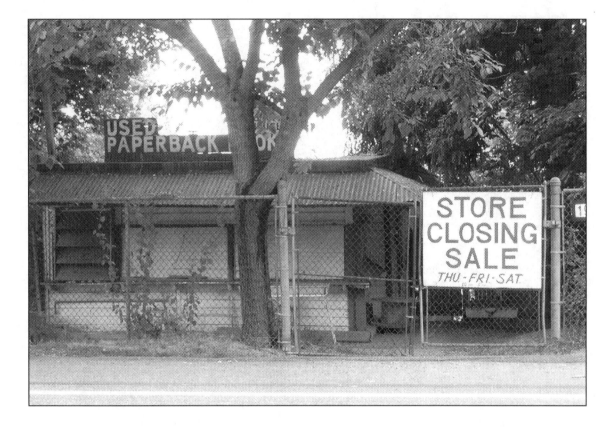

I recall an old mom-and-pop store. It was down the block from my childhood home. The white-haired owner was a writer, who sold used novels from his dilapidated shack. Pages were dog-eared. Spines were broken. Covers were faded. But I didn't mind at all.

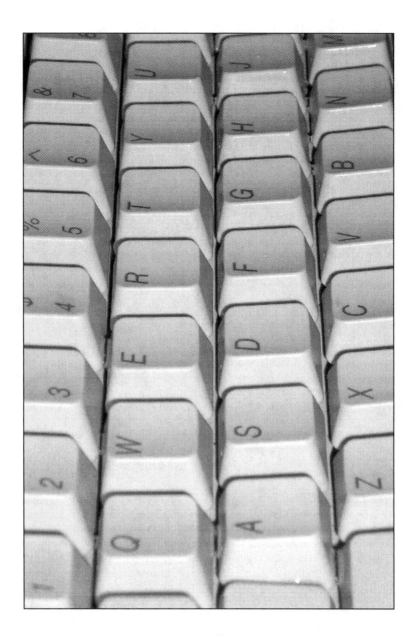

I am constantly typing. With today's technology,
button pushing is part of life. At work, we tap keys all day.
Then at home, we tap some more. We chat with chums.
We laugh out loud. We excitedly smile.
But no one hears. Or sees. Except the keys.

I detest weddings. I avoid them whenever possible. And I
secretly pray for rain. As a single individual, nothing pains
me more than the union of a woman and a man.
Until that improbable day when I get hitched.
Then I'll pray for sunshine and blue skies.

I attended a college game recently. The last names on the
uniforms were unfamiliar, but I cheered anyway. Whether
school or the pros, we root for logos. Not individuals.
Players change, but fans remain. All donned in
caps and colors of some corporate entity.

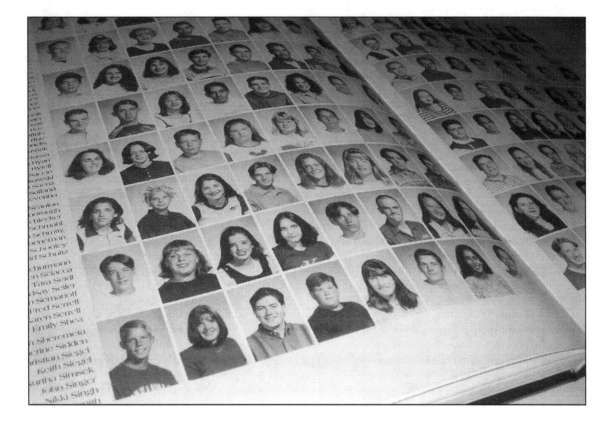

I rarely read my yearbooks. The long-lost faces. The dated,
scribbled messages. It's depression disguised in a glitzy
hardback. But, if anything, I respect the snapshots.
They show the world we were young. We existed.
It's all that saves us from total oblivion.

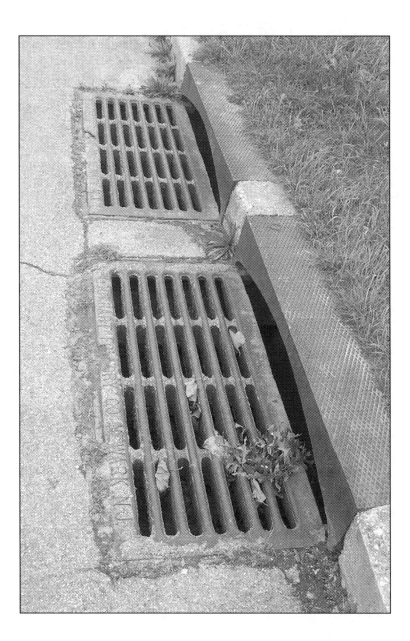

I dropped my keys in a sewer recently. I instantly froze.
Then I heard a soft splash. Within seconds, I pressed my
fretful face to the grate. But murk ruled. Past the manholes,
a whole world lies beneath our feet. A world no one sees.
Unless they drop their keys.

I'm surrounded by numbers. My bank account. My street
address. My cell phone. To many persons, we're just a
series of numerals. We're a voice following dialed digits.
Only loved ones see beyond the code. To them,
we are names. Faces. And individuals.

I keep a wooden chair beside my window. For hours, I'll often
sit. And stare. From my bleak seat, I see seasons changing.
Children aging. And young hearts ranging. But I don't open
the glass. Not even in heat. I just stare from my chair,
hiding behind pane.

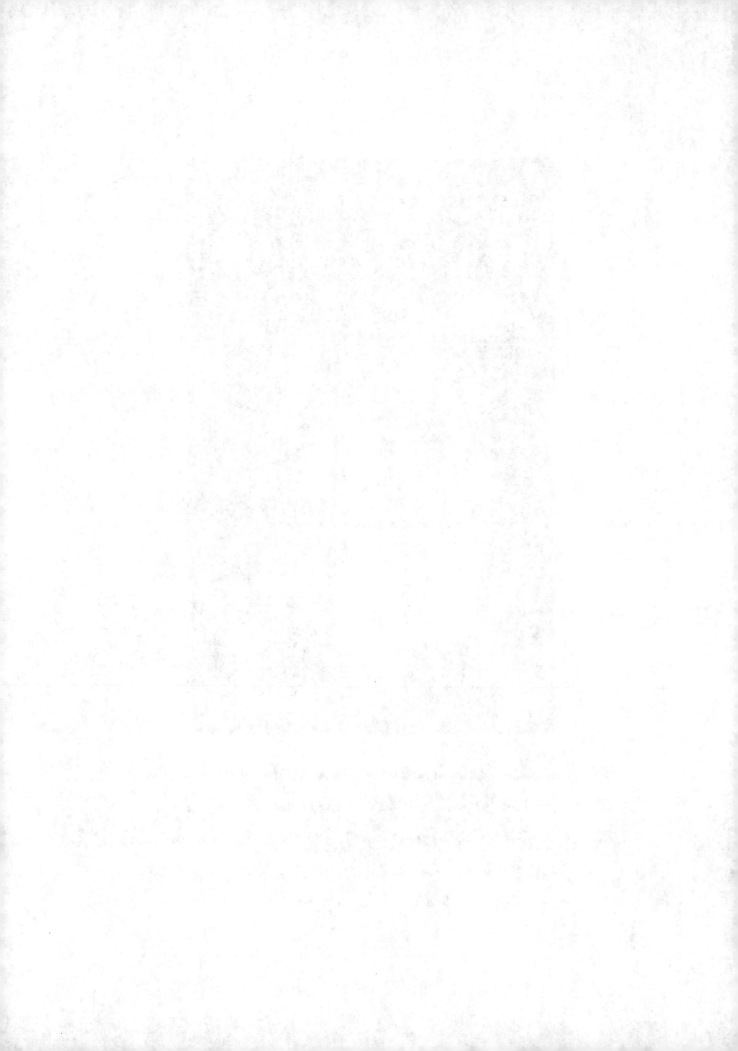

I have a clock in my bedroom. And on my desk. And in my car. Wherever I look, I'm face-to-face with florescent digits. Or tiny ticking sticks. They tell me when to eat. They tell me when to sleep. We spend each day racing time, just to start again tomorrow.

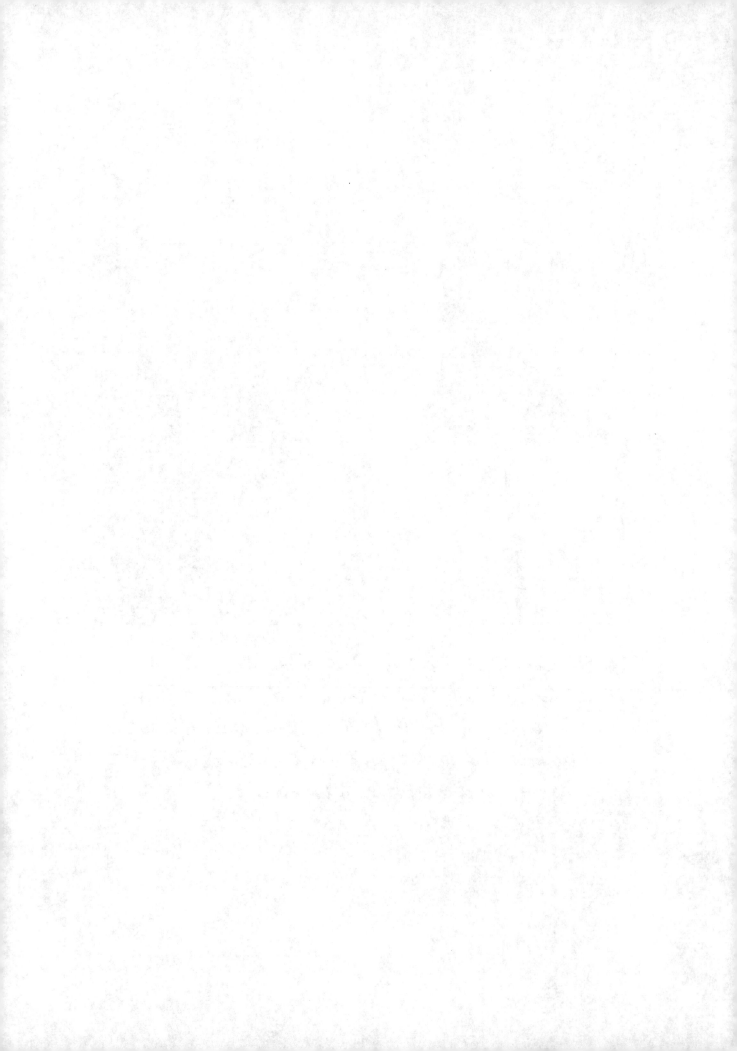

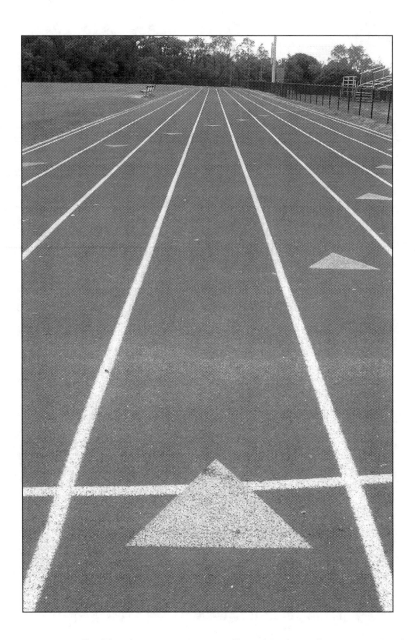

I jogged once. Following a friend's advice, I trotted the track
at a local high school. Spiritedly, I put on sweatpants and
stretched. Then I took off, letting the lines lead me.
But minutes later, I was wheezing. And others
were whizzing past me. Just like in life.

I find the ocean peaceful. And I especially enjoy boating.
It's a chance to get away. A chance to be alone. No people.
No pop-ins. Just me and my mind. I feel the breeze.
I hoist the sail. And I close my weary eyes,
knowing by morning it'll all seem like a dream.

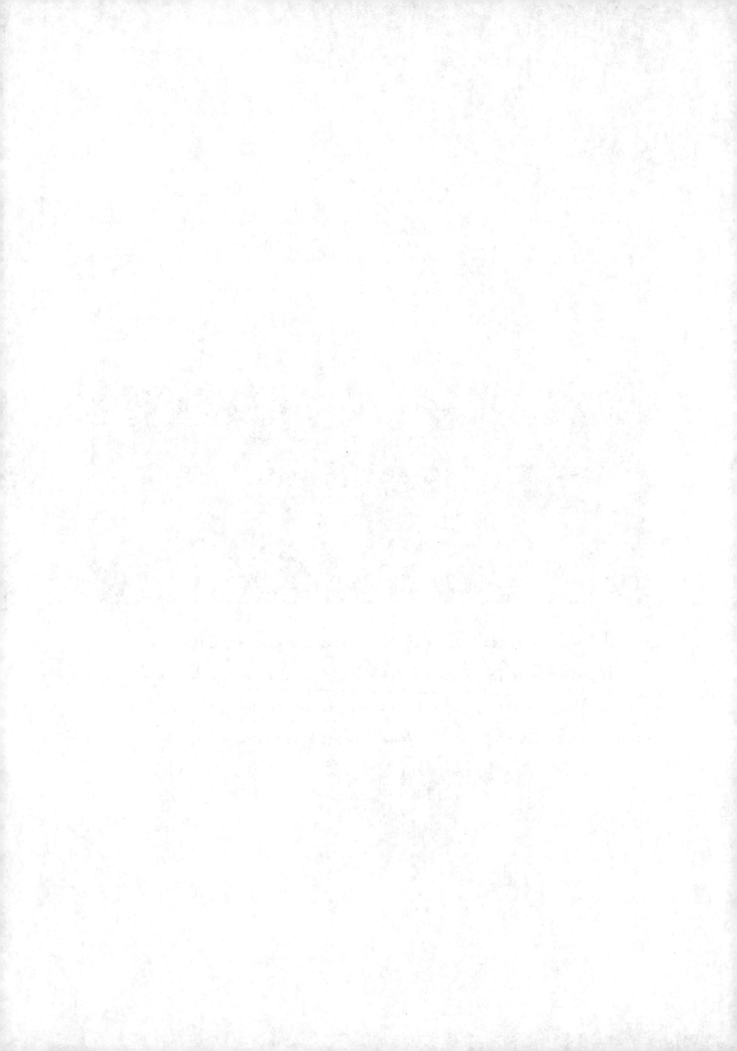

I passed a dealership recently. There were streamers all over.
And balloons above. Mostly likely, the decorations brought
would-be buyers. And families entered into debt. Sadly,
I studied the big ball. It banged wildly in the wind.
Almost like it wanted to escape.

I've lost touch with my old high school chums. But I recall
my schooldays often. A first kiss. A playful prank.
A violent bully. They are moments that shaped my being.
And today, other lives are permanently shaped.
It's the same halls. Just different faces.

I'm bad with directions. Send me east or west, and I'll likely end up north or south. Strangely, some people always seem to pick the proper path. They never veer off course. But I adore the detours. We can't recognize the right way unless we're lost now and then.

I avoid large cities whenever possible. The fast-paced life.
The cramped quarters. It's an uncomfortable experience.
But I marvel at the people. There's millions within miles,
and lights as far as the eye can see. People surrounding
people. All trying to make a name.

I keep tape on my desktop. And backup rolls in the top drawer. If a paper tears, I mend it at once. In seconds, it's good as new. But sometimes a simple splice won't do. There are rips beyond repair. And incurable cuts. Buying a blank sheet is the only answer.

I rarely ride buses. But I pass bus stops everyday. People are patiently waiting. Strangers stand side-by-side. For an instant, their lives intersect. Time and space collide. Then they part ways. They never meet again. And they never remember each other.

I plan a picnic each summer. With a basket and book, I plant
myself beneath a tree. But I rarely read. Instead, I'll stare
at the branches above, as they touch other twig tips.
Limbs intersect like lovers holding hands.
Before long, I leave. Giving them time alone.

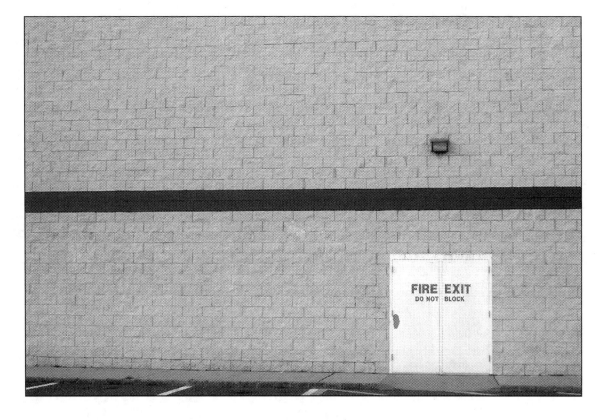

I see doors all over. Some are glass. Others wood. Some
swing. Others revolve. From emergency exits to garden gates,
doors are different. But they all have similarities.
They lead to new places. New people. New things.
And they're almost always closed.

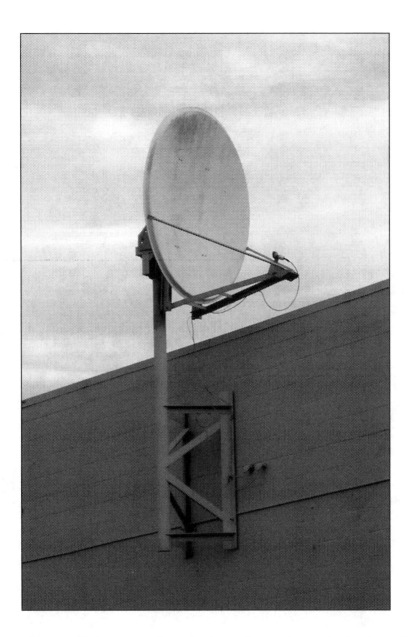

I see satellites all over. Roofs are dotted with dishes, looking
more like dirty sinks. For the opulent owners, some stations
just aren't enough. They want countless choices. With shows
they'll never see. Or songs they'll never hear.
But at least their home is high-tech.

I cruise the countryside often. I rubberneck. And I enjoy the
old-world scenery. From silos to soil, it's unspoiled by
pointless pavement and posh penthouses. Roads
are dirt. Food is farmed. Land is loved.
And I serenely smile from my cozy SUV.

I avoid videogames. While some people jump for joysticks,
I pull the power cord. But as a chunky child, I cherished
chomping tiny dots. Or leaping over bouncing barrels.
I'd memorize moves until my thumbs were numb.
Hoping my homework wasn't as tricky.

I never eat vegetables. Or fruit. From onions to oranges,
I always forgo the food. But some people are nutrition nuts.
They gulp down grapes and scarf up strawberries.
Most likely, they'll live a long life with healthy hearts.
But thankfully, I never eat the food.

I play piano periodically. When emotion strikes, I sit down
and stroke the keys. But I don't practice pieces. Instead,
I let my fingers freely dance. One note begets another.
It's a spontaneous performance. At times, my chords
are discordant. Just how I like them.

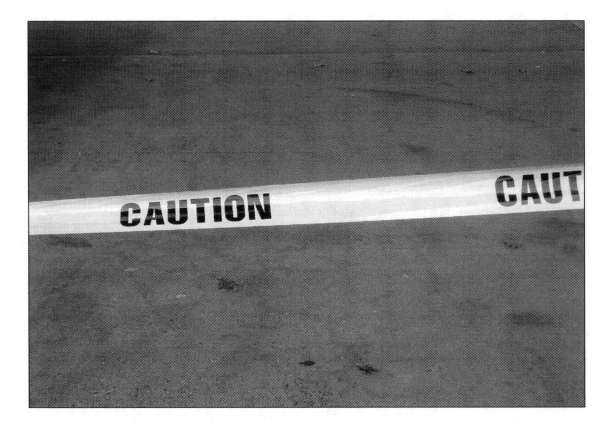

I passed a crime scene recently. Cop cars already left and
reporters had departed, but yellow tape still remained.
It was the only evidence that wrongdoing had occurred.
Curiously, I stopped. I looked around. Then I
drove off, disappointed I missed the chaos.

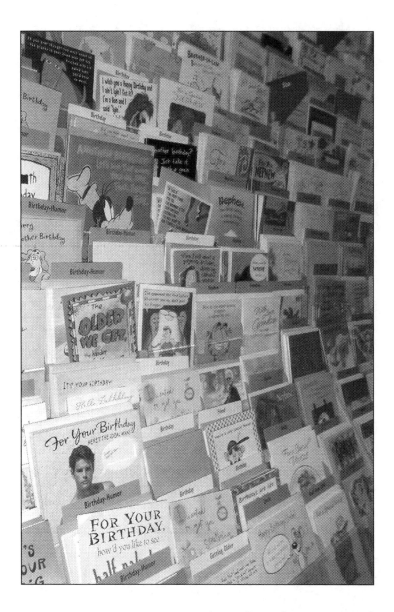

I get greeting cards constantly. Birthdays. Holidays.
There's an event every week. Thoughtfully, we roam for the
perfect poem, hoping to evoke laughter. Tears. Or both.
Hoping to uplift an old chum. Or reclaim a loved one.
With words we're too shy to speak.

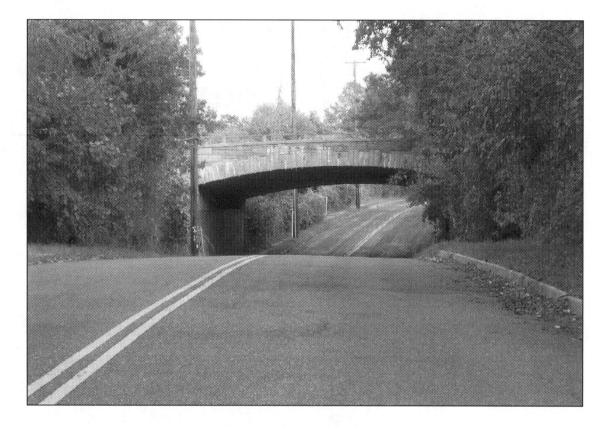

I steer clear of bridges. In fact, I'll find an alternate route
before using an overpass. The whole notion of shortcuts bugs
me. And land-linking bridges is the lazy man's way.
I'd rather walk across. Or swim. And if I drown,
I'll die knowing I didn't take the easy road.

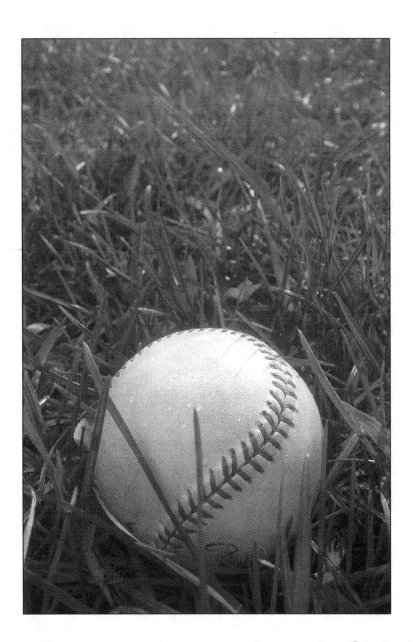

I saw a father and son playing catch recently. The boy's glove
outsized his head, but he dropped every throw. Still,
I glimpsed his giant grin from across the grassy field.
And his eyes were lit like a stadium. Despite his
clumsy catches, he cherished each pitch.

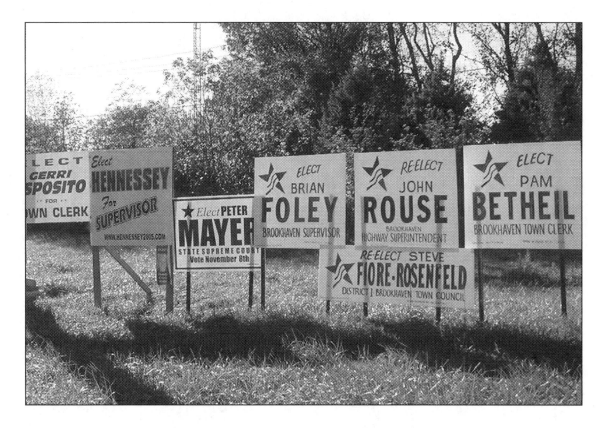

I don't vote. Not for Idols. All-stars. Or politicians.
But I can't avoid the ads. They jam avenues and airwaves.
They litter lawns. Self-satisfied contenders beg for ballots.
Mostly, they seek acclaim. But fame fades.
And I won't help create an unhappy has-been.

I drive slowly. Whether in first or second gear, I cruise
with complete caution. Every forward-moving mile is
a mini milestone. But when in reverse, I stamp the gas.
Backing up is easy. The people and places are familiar.
It's the unknown road that fears me.

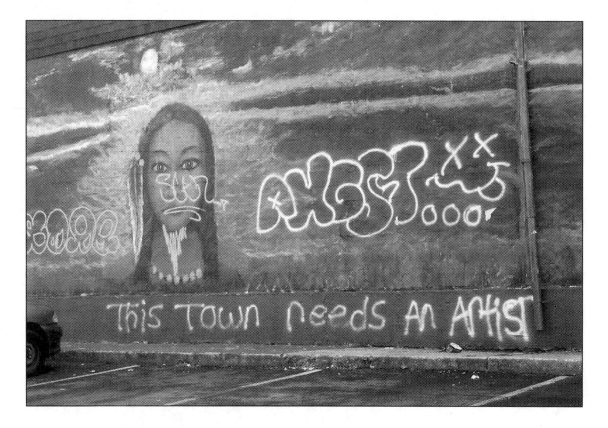

I admired an artist last month. With paints and passion,
he made a massive mural. A blank wall was brightened, and
passersby paused in awe. Days later, groups still gathered.
But this time, the buzz was over another artist.
One who refused to use a clean canvas.

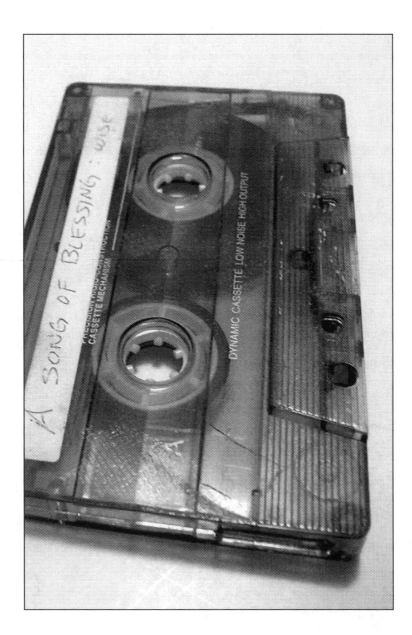

I rummaged through my closet recently. Old shoes and socks
were strewn about. And a battered box was buried beneath.
Without thinking, I reached for it. I opened it. Then
I closed it. Inside were dozens of dusty melodies.
With billions of bittersweet memories.

147

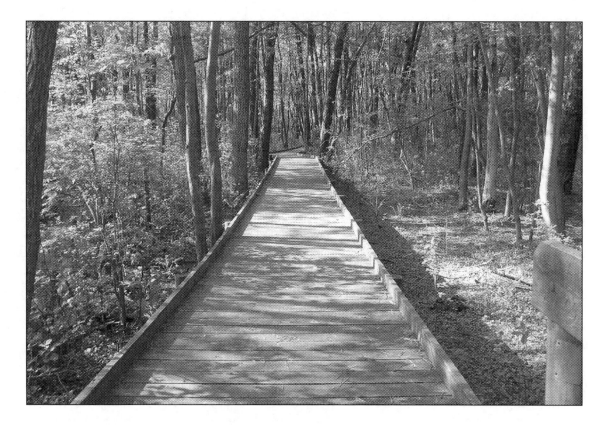

I wander the woods often. When I'm feeling frazzled, I flee to my favorite forest. A big boardwalk leads through leaves, twisting around trees. Beside me, squirrels scurry. Above, wind sings. Stress lessens with each step. Until I pass people. Then I'm edgy again.

I work in an office. Day after day, I'm crammed in a cubicle with a computer. Or occasionally, we convene in a conference room. If you ask me, the errands are easy. The challenge is acting cheery for customers and coworkers.
I studied media. Not theater.

I despise doorstops. Whenever I move, I immediately rid the rods from every wall. Instead, I'll let the warped doors swing wildly. Forcefully. They'll mark the moldings. And taint the paintjobs. In time, the dings get big. And walls get the beating they deserve.

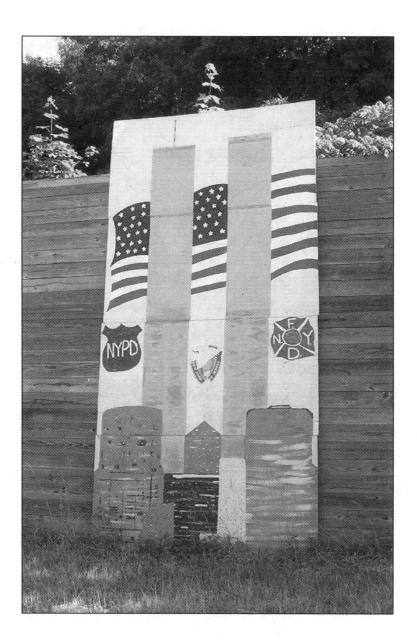

I travel the expressway everyday. And at the same spot,
I pass a massive painting. It sits against a sound barrier,
climbing forty feet. I feel small alongside it. Unimportant.
It's a homemade homage to heroes. An inspiring shrine.
Until the next calamity occurs.

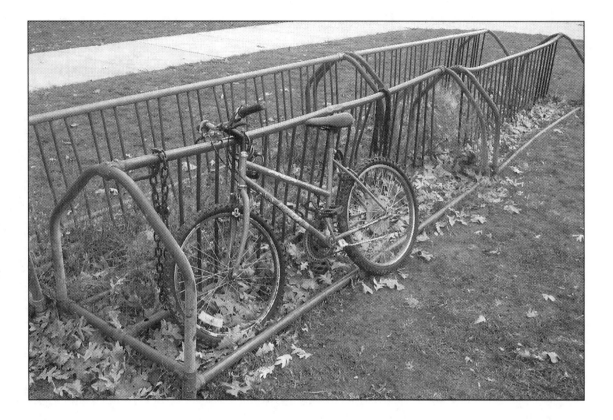

I used to be a little boy. And like most boys, I once owned
a bicycle. Everyday, I'd tour the same streets. I knew
every pothole. Every bush. Even today, I recall it all.
With rusty wheels, I'll think back. And I'll
nostalgically navigate the old neighborhood.

I rarely read. But sometimes, I visit my local library.
With frantic fingers, I browse bookshelves for enticing titles.
And after a choice chapter, I move to the next text.
Someday, I'll read a whole hardback. But for now,
there are too many pickings to commit.

I loathe license plates. From back bumpers, they let strangers identify us. Find us. It's a tracking system for troublemakers. Someday, I'll slyly unscrew the rear rectangle. And cruise incognito. Lost in a crowd of cars, I'll flail my arms in freedom. Until they're tied.

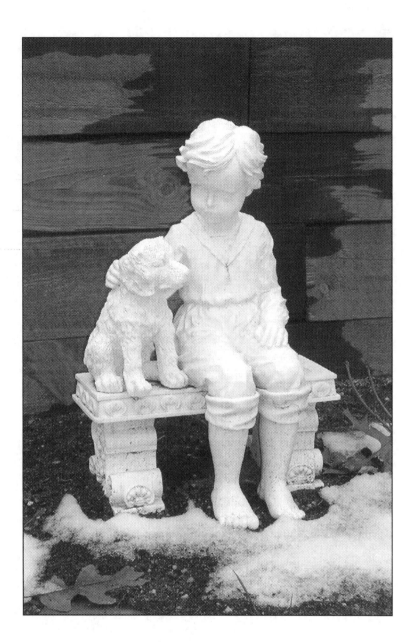

I saw a statue recently. While speeding to a store, the figurine
abruptly appeared. A boy and dog decorated a dirt bed,
showing deep devotion. Mesmerized, I pulled over.
And I lurked up the lawn. Content the friendship
was frozen in stone and unable to fade.

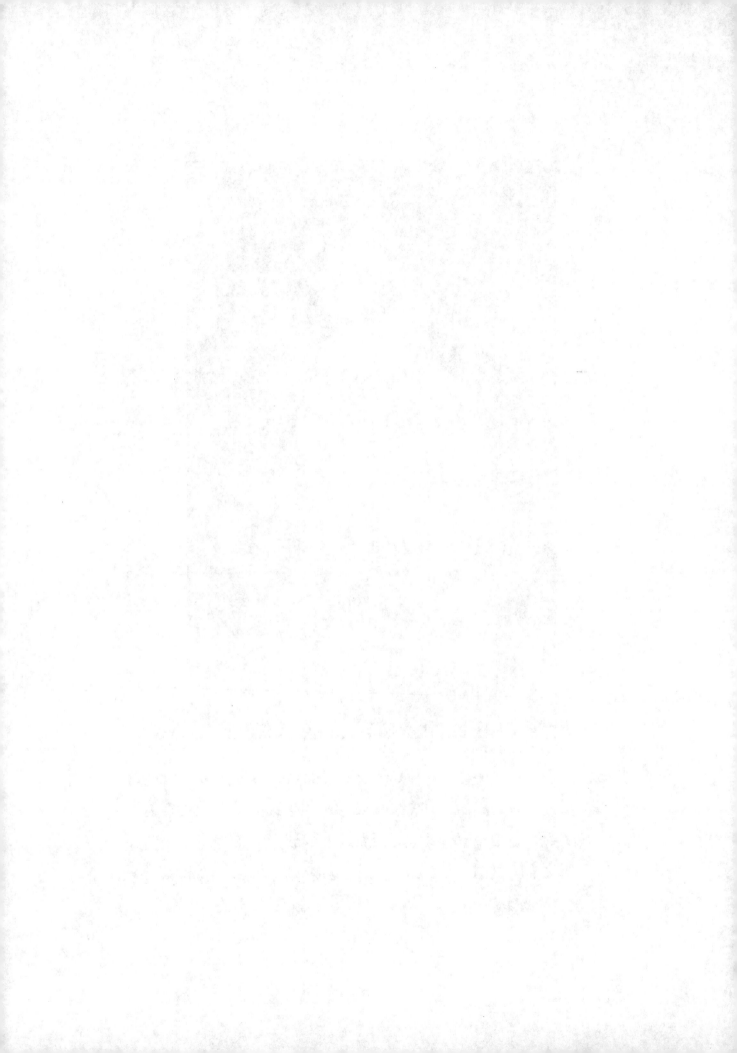

I visit a farm frequently. For a tiny fee, I can pick pumpkins
and look at livestock. Typically, pigs captivate the kids.
Their battling bodies attack every kernel of food. They hog
the dish. They butt heads. It's every boar for himself,
as onlookers laugh it up.

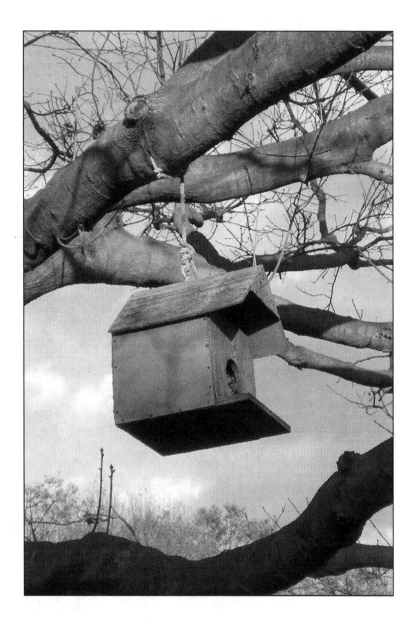

I built a birdhouse once. From my father, I collected a
woodblock and a toolbox. Within weeks, baby birds squeaked
as a mother filled beaks. Today, the branch is bare.
And the birds are grown with families of their own.
But I still hear their cheerful chirps.

I stood still on a sidewalk once. For minutes, I didn't budge.
I just watched cars as they flashed past. Two headlights. Two
tiny eyes. Then two taillights. After a while, beams blurred.
And cars contorted. The world was a whirlwind.
Until I closed my eyes.

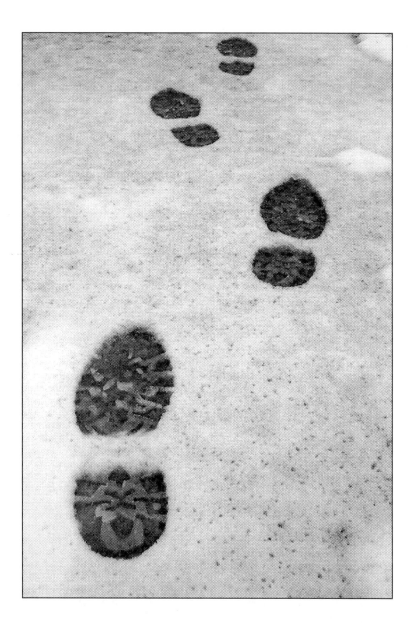

I walked a white trail recently. And eerily, I stumbled upon
unexpected footprints. Besides mine, they were the sole blots
in the smooth snow. Instinctively, I looked around.
But there was no one. Whoever made the marks
was gone. It was my chance to trample them.

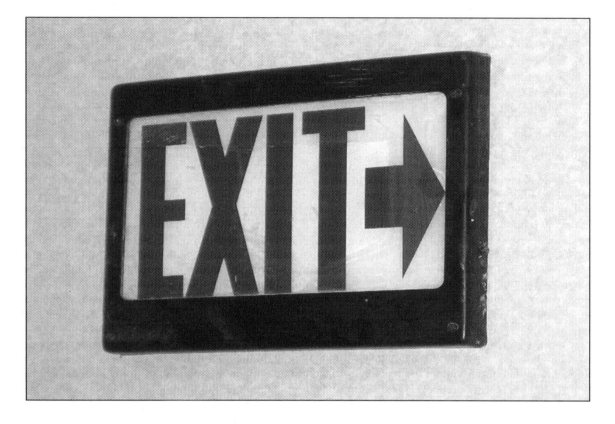

I evade exits whenever possible. In fact, just seeing an exit
sign makes me uneasy. With an arrow, exits offer an escape.
A getaway. Implying there's something to flee from.
Like a busy building. Or a hectic highway.
If an exit sign is present, I'd rather be absent.

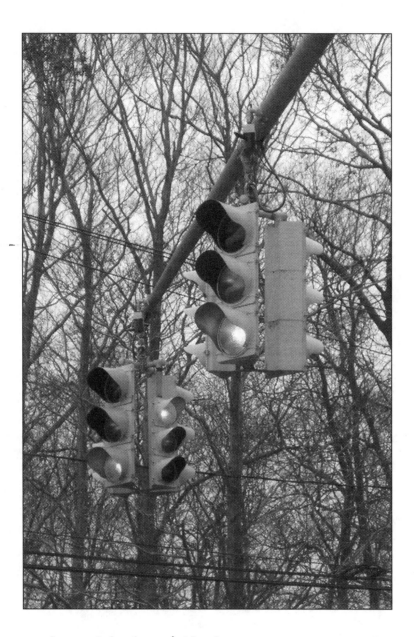

I always hit red lights. Whether on country roads or city streets, I never get green. Without warning, my relaxing ride is disrupted. I brake. And I rashly glare at a red circle. As I stop dead, others move ahead. In time, I get my green. But the ride just isn't the same.

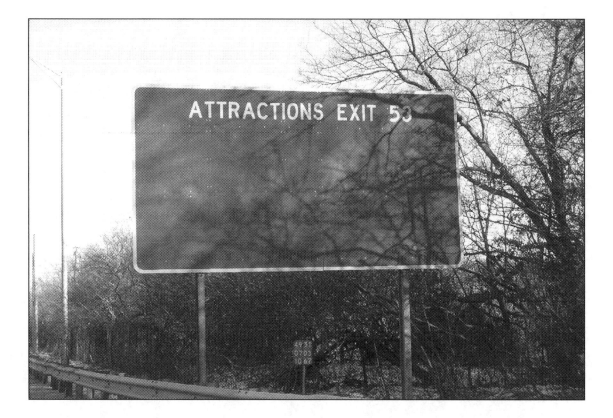

I saw a giant sign recently, towering along the roadside.
But besides shady branches, it was entirely empty.
Instinctively, passersby peeked at it. And tourists turned
their heads. But they didn't brake. Officials felt there
was nothing to see. And we're obliged to believe them.

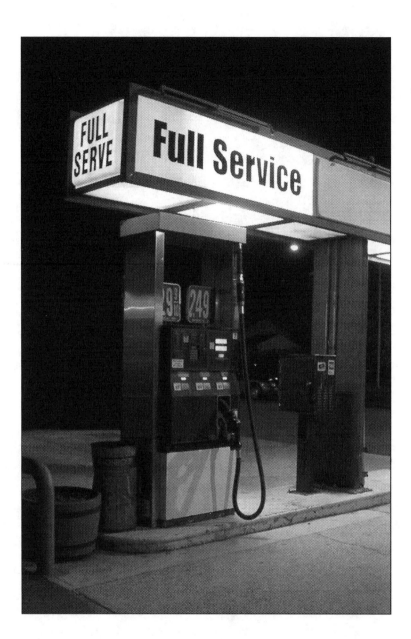

I get gas daily. But I rarely pay-at-the-pump. Old-fashioned
full serve is my favorite. Even on icy nights, I'll
compassionately call on a turtlenecked attendant.
With a smile, they faithfully fill tanks. And we say,
"Thanks." Until machines make their jobs obsolete.

I visited a college campus recently. And like all academies,
peer pressure ruled. Predatory groups promoted logos,
offering instant kinship. Like street gangs. Or firms.
For followers, individualism is unimportant.
They prefer pals. Even if the friendship is fixed.

I don't smoke. For whatever reason, the sexiness of cigarettes
never tempted me. But contaminated clouds surround us.
From chimneys to chain smokers, we exist in mist. At times,
I hold my breath. And I snub polluted puffs.
Wishing skies could do the same.

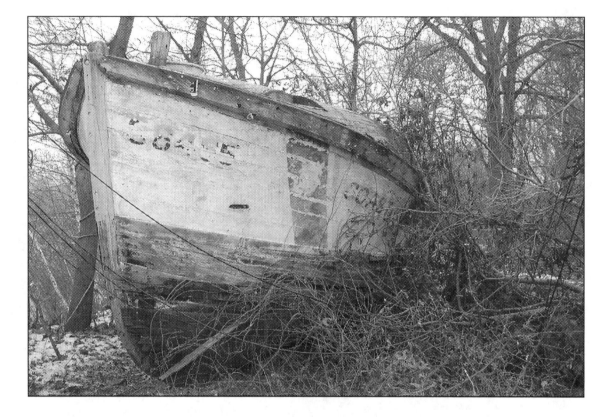

I found an old boat once. But not near water. Instead, it was abandoned in branches, far from the still seas its hull once knew. Curiously, I climbed inside the decaying craft. And I grabbed the weathered wheel. Letting the vessel live again, if only for a moment.

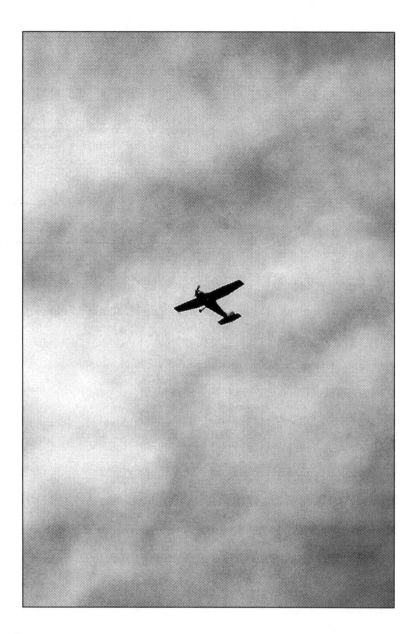

I've always wanted wings. Like most folks, the freedom of
flight fascinates me. But I won't pilot a plane. Or look at a
cockpit. Artificial wings are a ruse. People hide inside, while
planes glide. If you ask me, true flights depart at night.
When we drift where we want.

I can't act. For me, even white lies are a stretch. And my poker face is second-rate. But others are expert performers. They can adopt accents. Or cry or cue. Now and then, I envy their ovations. But in truth, the applause isn't theirs. It's for them being someone else.

I steal stuff often. Mostly batteries or bubblegum. It's too
hard to rob bigger things. Cameras are all over, recording
each motion. If we cheat, our face is filmed. But sometimes,
bandits plan a perfect crime. And getaway with green.
Only to own items they never needed.

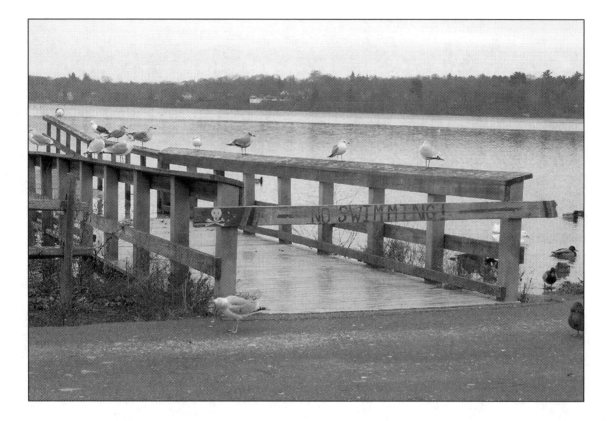

I only swim in pools. Never in natural water. The murky
surface scares me. But many people plunge not knowing
what's below. They dive headfirst. They skinny-dip.
Someday, I'll be gutsy. And maybe wade to my waist.
Watching as others splash and laugh.

I live in a brick building. From drizzle to blizzards,
red rectangles keep me warm. And dry from storms.
With unassuming unity, they stand side-by-side like loyal
soldiers. Sometimes, I'll thank them. I'll press a palm
to the brave blocks. Then I'll scurry inside.

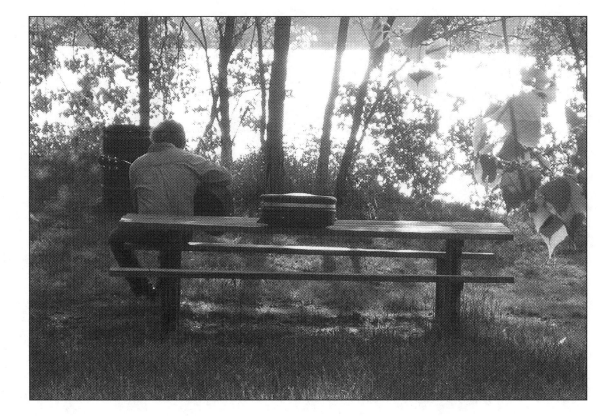

I saw a man by the lakeside recently. He was sitting alone.
But yet he wasn't. He was surrounded in song.
He was strumming and humming. Amid this crazy world,
he found harmony. Comfort. And I shut my eyes as he sang,
hoping to feel that peace too.

Michael R. Ebert is also the author of:
"Diary Of A Shy Guy" (2005)
"Schoolgirl Stalker" (2005)
"The Curse Of Lake Ronkonkoma" (2002)
www.michaelrebert.com